Using Accessory Equipment

Read *Using Accessory Equipment* and learn how to—

- Use different types of lenses to produce the effects you want in your photographs.

- Use electronic flash for great control over lighting—indoors and out.

- Get spectacular effects with a variety of filters.

- Protect your valuable equipment from damage.

THE NO NONSENSE LIBRARY

OTHER NO NONSENSE PHOTOGRAPHY GUIDES

Composing Photographs
Photographing People
Photographing Your Vacation
Using Creative Techniques
Using Existing Light

OTHER NO NONSENSE GUIDES

Car Guides
Career Guides
Cooking Guides
Financial Guides
Health Guides
Legal Guides
Parenting Guides
Real Estate Guides
Study Guides
Success Guides
Wine Guides

USING ACCESSORY EQUIPMENT

A KODAK Book

MICHAEL O'CONNOR

Longmeadow Press

USING ACCESSORY EQUIPMENT

Published by Longmeadow Press, 201 High Ridge Road, Stamford, Connecticut 06904. No part of this book may be reproduced or used in any form or by any means, electronic or mechanical, including photocopying, recording, or by an information storage and retrieval system, without permission in writing from the publisher.

No Nonsense Photography Guide is a trademark controlled by Longmeadow Press.

ISBN 0-681-40732-8

Produced by The Image Bank in association with Eastman Kodak Company, Rochester, New York.

Kodak is a registered trademark of Eastman Kodak Company and is used under license from Kodak.

The Image Bank® is a registered trademark of The Image Bank, Inc.

Printed in Spain

0 9 8 7 6 5 4 3 2 1

Producer: Solomon M. Skolnick; *Managing Editor:* Elizabeth Loonan; *Editors:* Terri Hardin (The Image Bank), Margaret Buckley (Kodak); *Caption Assistance:* Karen McLean; *Production Director:* Charles W. Styles (Kodak); *Production Coordinator:* Ann-Louise Lipman (The Image Bank); *Editorial Assistant:* Carol Raguso; *Production Assistant:* Valerie Zars; *Photo Researchers:* Natalie Goldstein, Lenore Weber; *Copy Editor:* Irene S. Korn; *Art Direction and Design:* Chase/Temkin & Associates, Inc.

Cover photographs, left to right: A. T. Willett, Melchior DiGiacomo, Jake Rajs

For information about the photographs in this book, please contact:
The Image Bank
111 Fifth Avenue
New York, NY 10003

TABLE OF
CONTENTS

INTRODUCTION

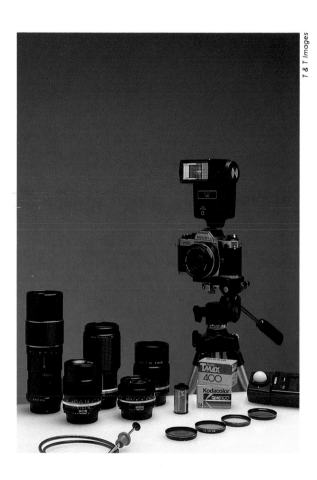

It's easy to find useful accessories for even the simplest 35 mm camera. Many of these are inexpensive, easy to use, and can expand your picture-taking capabilities dramatically.

Why should you use accessory equipment? Although many of today's automatic cameras claim to "do it all," they judge every photographic situation by its common denominator. This may not always give you the best results and it leaves you, the photographer, without much control over how your pictures will come out.

Using Accessory Equipment introduces you to the most popular types of accessories for 35 mm cameras: lenses, electronic flash units, filters, and camera supports. It includes practical information on buying and using these accessories, non-technical explanations of how they work, and advice on when—and when not—to use them. You'll even learn how to make your own inexpensive accessory equipment!

Although the discussions center mainly on the single-lens-reflex (SLR) camera, which is most easily accessorized, you will also learn how to use the automatic functions of a non-SLR camera to make more dramatic and successful photographs.

Start by reading this book from beginning to end and note the types of accessory equipment you find most interesting. Try all the techniques to discover what will work for you. If you find terms you don't understand, check the glossary of photographic terms at the back of the book.

One of the best ways to learn photography is to look at photographs—a lot of photographs. Look through this book and decide which pictures you like most. Study them to see exactly what was used to achieve the effect.

View the ideas, techniques, advice, and photographs in this book as points of departure for your own creativity. Outside of some technical considerations, there really are no hard-and-fast rules in photography. Do some experimenting, and work at a technique until you can use it confidently. Don't worry about getting great pictures the first time, but try to become secure in handling the accessories of your choice.

LENSES

François Dardelet

Have you ever taken photographs that you thought were going to be great—only to discover when the pictures came back from the lab that your camera didn't record the scene as you perceived it? Perhaps your attention was riveted on your subject to the exclusion of everything else, but the camera lens dutifully included a myriad of other elements surrounding a very small image of your subject.

By learning about and using the many types of accessory lenses that are available, you can easily avoid this type of disappointment. Owning a variety of lenses—or just a zoom lens—can expand your photography aesthetically as well as technically. A choice of lenses provides you with control over your pictures. By using lenses of different focal lengths, you can also manipulate the depth relationships of the elements in a scene.

Most 35 mm single-lens-reflex cameras let you change lenses easily and rapidly by pushing a button and giving the lens a quarter-turn. And because the viewfinder lets you look directly through the lens, you can see exactly what effect different lenses will have.

A rangefinder camera isn't quite so versatile. Although you can change lenses on certain 35 mm rangefinder cameras (usually the more expensive models), you still must view the scene through a separate window—not through the lens. This makes it more difficult to judge exactly what the photograph will look like. And while the viewfinders on some rangefinder cameras have crop marks that outline the approximate field of view for various popular lenses—some even have a provision for attaching separate viewing lenses of the same power—these features let you see only approximately what the camera lens is seeing.

In Part One, we will discuss types of accessory lenses—normal, wide-angle, telephoto, zoom, and macro lenses—what they do, and how easy they are to work with. We will also discuss accessories that you can use to adapt your normal lens for close-up photography; cable releases and supports that prevent camera shake; and items that can keep your camera lenses and other equipment in good working order.

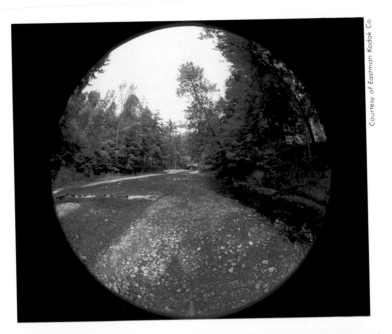

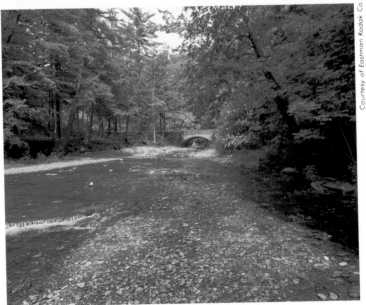

USING ACCESSORY EQUIPMENT

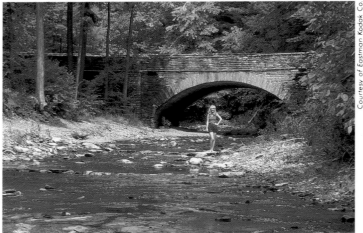

These photographs illustrate the effects of different lens focal lengths used at the same camera-to-subject distance. The top left photo shows the effect of an 8 mm fisheye lens, which produces a 180-degree hemispheric perspective (notice the great depth of field). The bottom left picture, taken with a 50 mm normal lens, is similar to what your eyes would see. The top right photo was taken with a moderate 105 mm telephoto lens, and the bottom right photo with a 200 mm telephoto lens. Telephoto lenses allow you to isolate the subject and make distant subjects appear larger.

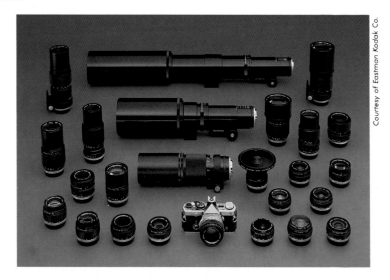

Courtesy of Eastman Kodak Co.

NORMAL LENSES (AND ACCESSORIES)

A *normal lens* for a 35 mm camera has a focal length of approximately 50 mm. The 50 mm lens is referred to as a normal lens because its angle of view closely approximates what we see with our eyes. It is versatile and useful for a wide variety of common photographic subjects from broad landscapes to portraits. Most normal lenses are fast—they have a large maximum aperture—which makes them very useful for photography in low-light situations.

A number of lens accessories can adapt your normal lens for close-up photography of small objects. These are auxiliary close-up lenses, extension rings, reversing rings, and bellows, all of which allow you to focus at much closer distances and increase the magnification of your subject. You may want to consider purchasing such accessories if you shoot close-ups infrequently and don't want to invest in a macro lens.

There is also the split-field lens, which attaches to your normal lens and helps you photograph subjects close and far away at the same time. This lens is more like a filter in many ways, and is more fully discussed on page 71.

The opposite page shows just a sampling of the many lenses available. A normal lens has a focal length equal to the diagonal measurement of the film frame. Its field of view corresponds to the normal field of view of the human eye. The 50 mm lens is a very versatile tool that is basic to the 35 mm system; be sure to explore its potential before you purchase other lenses.

Matthew Loonan

Matthew Loonan

WIDE-ANGLE LENSES

There are two basic types of wide-angle lenses: *standard,* which has a focal length between 21 and 40 mm; and *fisheye,* which has a focal length of less than 21 mm.

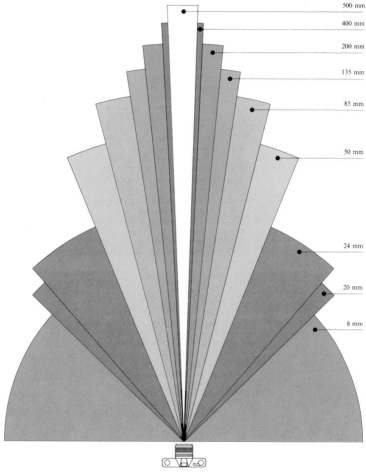

500 mm
400 mm
200 mm
135 mm
85 mm
50 mm
24 mm
20 mm
8 mm

This diagram shows the angle of view covered by lenses of different focal lengths.

USING ACCESSORY EQUIPMENT

Standard wide-angle lens. A standard wide-angle lens takes in a wider angle of view than a normal lens; this means that at the same camera-to-subject distance, it covers a larger part of the scene. A wide-angle lens is especially useful when you can't back up to include more of the scene in a photo.

Wide-angle lenses distort the subject by bending parallel lines so that they appear to converge in the final image. The shorter the focal length of the lens, the more distortion it produces. Distortion with 24 mm and 21 mm lenses can be very obvious.

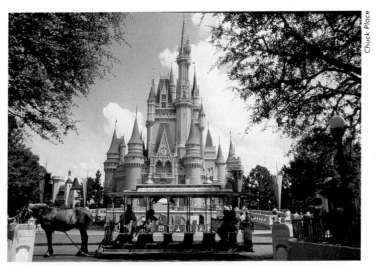

A 20 mm wide-angle lens covers a field of view equal to approximately 90 degrees. Wide-angle lenses are useful for interior and architectural photography, because they let you photograph large subjects at relatively close distances.

However, you can use this distortion to great advantage. You can stretch, exaggerate, or emphasize any element in your picture by placing it at the edge of the field of view. You can make a fence appear longer by photographing it from a three-quarter angle or make a building appear taller by photographing it up close from a low angle. If you want to minimize distortion, photograph head-on, and keep your lens parallel to the ground.

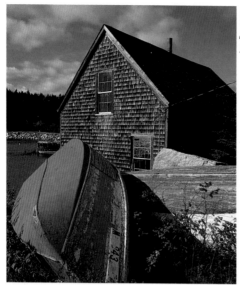

Joe Devenney

When you use a wide-angle lens, remember that any lines near the edges of the frame will be distorted. In the photograph at the left, the proportions of the house appear normal, while the boat in the foreground is attractively curved.

The optical properties of a wide-angle lens provide other photographic benefits as well. It lets you focus at shorter subject distances than a normal lens. Because it produces less magnification and is generally smaller and lighter, it's easier to hold the camera steady, and you can work at slower shutter speeds. Greater depth of field also makes focusing less critical.

Fisheye lenses. A wide-angle lens with a focal length shorter than 21 mm is commonly referred to as a fisheye lens because the large front element protrudes much as the eye of a fish does.

Fisheye lenses produce a great deal of distortion. Straight lines that do not pass through the exact center of the frame will appear curved. The closer the straight line is to the edge of the frame, the more pronounced the curve.

The most common use for fisheye lenses is in architectural photography—especially in interiors, where the photographer can't move farther away but wants to include as much of the room as possible.

USING ACCESSORY EQUIPMENT

When used effectively, the distortion created by a wide-angle lens enhances the dynamics of a photograph, as shown on these pages. It's important to understand the effects of different focal lengths so that you can use lenses creatively.

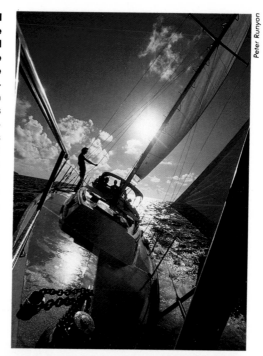

Peter Runyon

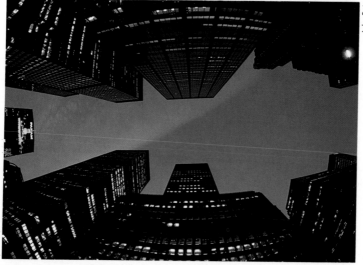

Jake Rajs

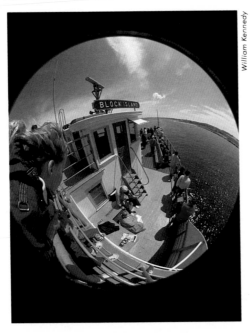

A standard fisheye has an extremely wide angle of view, but greatly distorts the subject.

There are two types of fisheye lenses. *Standard fisheyes,* which have a focal length between 8 and 12 mm and cover a 180-degree angle of view, produce a circular image (the corners of the photo will be black). *Full-frame fisheyes,* which have a focal length between 15 and 20 mm, produce an image that fills the entire frame. Like the standard fisheye, the full-frame fisheye has an extremely wide angle of view and produces a great deal of distortion.

Fisheye lenses are very expensive and can be tricky to use, even for professionals. Their extremely wide angle of view often makes it difficult to keep unwanted elements (including your hands, feet, and tripod legs!) out of the picture. The convex front element makes it impossible to attach protective filters. You can use other filters only if you can insert them into the body of the lens. The extremely wide field of view may also cause exposure metering problems in scenes that include a large bright expanse such as the sky.

USING ACCESSORY EQUIPMENT

TELEPHOTO LENSES

Telephoto lenses for 35 mm cameras have focal lengths longer than 55 mm. They provide more magnification than normal or wide-angle lenses, and let you make larger images of subjects that are farther away.

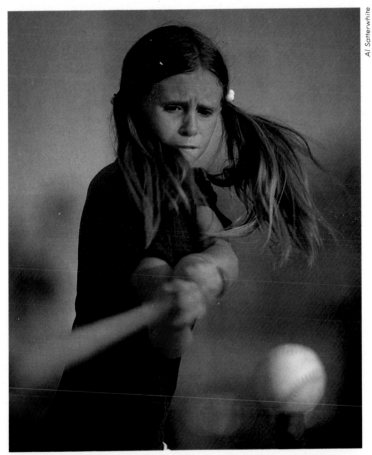

Al Satterwhite

The narrow angle of view produced by a telephoto lens lets you isolate the subject while maintaining your camera-to-subject distance. The shallow depth of field blurs distracting backgrounds and emphasizes the subject.

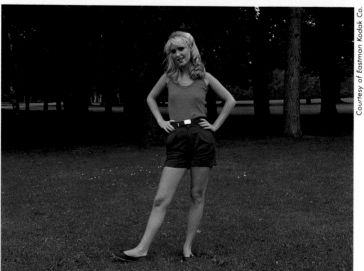

Courtesy of Eastman Kodak Co.

In these photographs, the photographer kept the size of the subject constant by changing the camera-to-subject distance. On page 20, the lenses used were a 24 mm wide-angle (top), a 50 mm normal

USING ACCESSORY EQUIPMENT

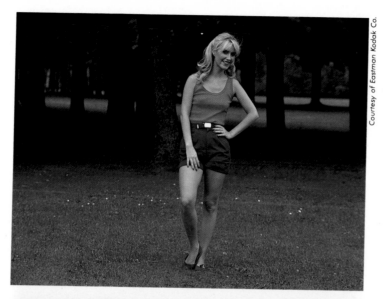

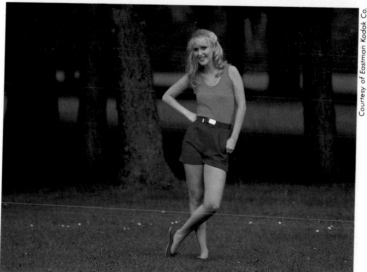

(bottom); on page 21, a 105 mm telephoto (top), and a 200 mm telephoto (bottom), were used. The background appears closer as the focal length increases.

These lenses have a number of interesting optical properties that you can use to create effective photographs. For instance, the longer the telephoto lens is, the shallower the depth of field is at a given aperture. This lets you isolate a single element in a scene or soften a distracting background by throwing it out of focus.

Telephoto lenses also flatten perspective and decrease the perception of space so that objects at different distances from the camera appear to be closer together.

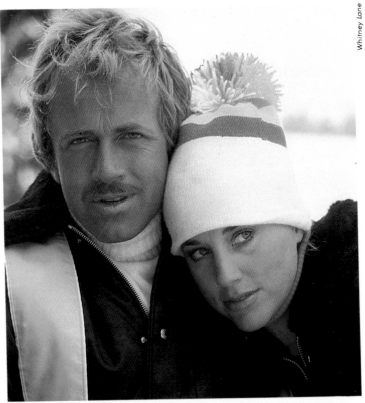

Whitney Lane

By isolating a portion of the field of view, telephoto lenses make distant subjects appear larger. They often create a sense of intimacy that draws the viewer's attention.

USING ACCESSORY EQUIPMENT

Short telephoto lenses. A telephoto lens with a focal length shorter than 200 mm is frequently referred to as a short or moderate telephoto lens. The most popular of these are 85 mm, 105 mm, 135 mm, and 180 mm. The shorter lengths (85 mm and 105 mm) are ideal for portraiture; they let you work at a comfortable distance from your subject and still have a large image in the frame. A slight flattening of perspective is generally flattering to faces, and the shallower depth of field diminishes the background. Lenses in the 135 to 180 mm range are great for candid photography. You can work at a distance and remain relatively unobtrusive, while your subject still fills a good deal of the frame.

Long telephoto lenses. A lens in the 300 to 1000 mm range generally is useful only in special situations. The most common uses of extremely long telephoto lenses are in wildlife photography and professional sports photography, when the photographer must work at great subject distances.

These lenses are quite expensive and have limitations. If you are thinking of buying a long telephoto lens, you should consider the following:

LONG TELEPHOTO LENSES...

- are useful only in brightly lit situations because they have small maximum apertures. Even in bright light, the image you see through the lens is relatively dark compared to the image you see through a shorter lens with a larger maximum aperture.
- have very limited depth of field, so focusing is critical.
- are heavy and difficult to hold steady. The degree of magnification makes the effects of camera movement more obvious, so you will need to mount your camera on a tripod or use a very fast shutter speed.

These photographs illustrate how a telephoto lens brings the subject closer. In the architectural details above, three-dimensional objects appear flattened.

USING ACCESSORY EQUIPMENT

In the photograph at the right, a telephoto lens captured the action without disturbing the subject.

Melchior DiGiacomo

Even the movement of the viewing mirror inside an SLR camera can cause enough camera shake to blur the image. This is why many professional photographers use the mirror-lock feature when they work with an extremely long lens.

Perspective compression, or foreshortening, is very obvious with lenses longer than 400 mm. As a result, they can make a moon, mountains, or some other background object loom very large over a foreground subject.

Whenever you use a telephoto lens, a camera support is invaluable. A sturdy tripod will add to the professional look of your photographs by preventing camera shake. Choose a tripod that is suited to your needs, such as a collapsible one for travelling, or one with a quick-release system for spontaneous action. Whatever type you decide on, buy the best one you can afford.

John Madere

Zoom lenses offer great versatility. One lens can cover a variety of situations; with just a couple of zoom lenses, you can cover a range of focal lengths from wide-angle to long telephoto. Zooming allows you to crop the subject easily without changing the camera-to-subject distance.

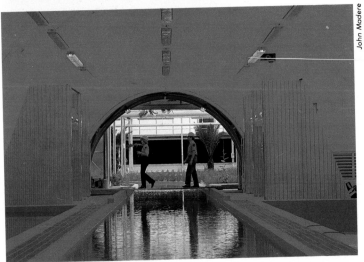

John Madere

USING ACCESSORY EQUIPMENT

ZOOM LENSES

Zoom lenses are adjustable over a range of focal lengths, and are usually more expensive, longer, and heavier than fixed-focal-length lenses. On the other hand, a single zoom probably costs less and weighs less than the group of fixed-focal-length lenses you would need to cover the same range. With as few as two zoom lenses, you can cover a wide range—from moderate wide-angle to fairly long telephoto—and have a continuously variable range in between the standard lens lengths! Zoom lenses used to be less sharp than fixed-focal-length lenses, but this is no longer the case with high-quality zoom lenses.

Although some very expensive zoom lenses cover an extraordinary range of focal lengths (such as 35 to 200 mm), most zooms fall into three general categories: A *wide-angle zoom* typically covers a range from about 24 to 50 mm, and is used primarily for group portraits or interiors that have a limited choice of camera location. A *mid-range zoom* covers a range from 35 to 85 mm, and serves as a "general" lens. A *telephoto zoom,* which covers a range from about 80 to 200 mm, is the most common. This lens is ideal for portraiture, amateur sports, and some wildlife photography.

Zoom lenses come in a variety of focal-length ranges, offering the advantage of in-between focal lengths. Most zooms have a maximum aperture of f/3.5 or f/5.6, which is fine for outdoor photography, but may limit your options in low-light situations.

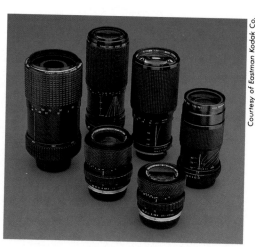

Courtesy of Eastman Kodak Co.

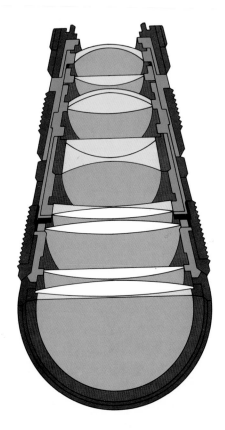

Zoom lenses contain as many as 18 separate glass elements. As the relative position of the lens elements changes, the focal length and the magnification of the image changes.

Many zoom lenses also offer a macro, or close-focusing, function. Although not as powerful as a real macro lens or many close-up attachments, the macro setting can come in handy for copy work, nature photography, and other kinds of close-up photography.

Zoom lenses are usually slower than standard lenses, and have maximum apertures of $f/3.5$ or smaller. This can be a problem in low-light situations, especially because they weigh more and are more difficult to hold steady at slow shutter speeds. Some zoom lenses have a variable maximum aperture that's determined by the focal length you select; the largest aperture is available at the shortest setting.

USING ACCESSORY EQUIPMENT

MACRO LENSES

A macro lens is designed for close-up photography. Because it can focus at much shorter subject distances than a standard lens, it provides greater magnification of small objects. The lens usually has an extremely flat field (see glossary under *flatness of field*) for optimum edge-to-edge sharpness.

The power of a macro lens is generally expressed as a magnification ratio—the actual size of the subject in relation to the size of the image on film. For example, a 1:1 magnification ratio indicates that the sizes are identical. Most true macro lenses have a maximum magnification ratio of about 1:2; this means that they reproduce the subject at half size. A normal 50 mm lens has a magnification ratio of about 1:7 at its closest focusing distance.

You can also use macro lenses for normal photography. They usually have focal lengths between 50 and 105 mm, with 55 mm the most common.

With close-up equipment, you can explore small intricate subjects and render fine details. A 50 mm macro lens lets you focus at 9 inches from the subject for a magnification ratio of 1:2.

Murray Alcosser

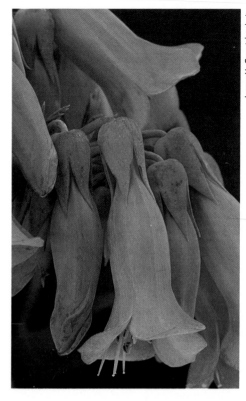

James H. Carmichael, Jr.

A close-up lens captured this group of delicate flowers, and revealed their exquisite functional design.

If you're considering a macro lens, think about the subjects you photograph most often and the distances you typically use to take close-ups. For instance, with a longer lens you can work farther from your subject. The 18- to 24-inch working distance of a 105 mm macro is more practical for nature photography, while the 8- to 12-inch distance of a 50 mm macro is more suitable for photographing stamps and coins.

Always focus very carefully when you use a macro lens for close-ups, because depth of field will be very shallow. Use a tripod if possible. The extreme magnification exaggerates camera movement, so use either a cable release or a self-timer. Try to keep your subject completely still. Outdoors, you may be able to shield your subject with a wind screen.

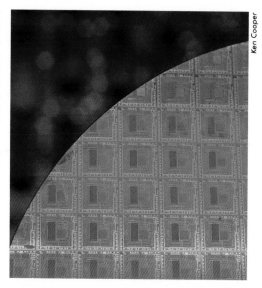

Nature and technology lend themselves to the realm of close-up photography. The fine details of this silicon wafer take on a magical quality as they are abstracted.

Ken Cooper

TRAVELING WITH YOUR LENSES

After you invest in a few accessory lenses, you may want to purchase other equipment that will protect them from damage and keep them working their best. For instance, your lenses may come with lens caps for safekeeping, but while you have a lens attached to your camera, you can use a clear or UV filter to protect it from smudges and other damage.

A lens hood helps prevent flare by shielding the lens from direct light from the sun or other bright sources.

In close-up photography, as with telephoto lenses, you'll often need a camera support such as a tripod, a monopod, or a clamp-pod to prevent the camera shake that can ruin your best efforts. Although tripods are sturdiest, monopods (which have only one leg) may be more convenient to use—especially when you're working in close quarters. Clamp-pods will attach to any stable surface, such as a chair or a table, and are easy to carry.

You can also experiment with many different types of remote triggering devices and cable releases for tripping the camera shutter from a remote position. Made from thin, flexible wire,

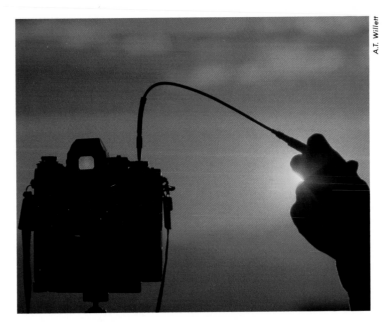

A.T. Willett

these releases can help eliminate vibration that might occur even when the camera is mounted on a tripod or other steadying surface.

Of course, one of the most important accessories to have when you're travelling is a sturdy, easy-to-use camera bag. Camera bags come in a variety of materials, including canvas and leather; prices range from $40 to $400.

When you purchase a camera bag, the first consideration is size. How much equipment do you expect to have? The bag that is best suited to your needs may not be the most expensive.

How well will the bag protect your equipment? Some bags have foam-covered inserts that attach with Velcro; these will insulate your equipment from shock and can move around to accommodate different accessories. (Avoid bags that have foam insulation built into the sides and bottom; they can trap moisture and harm your equipment.)

Finally, look for comfort and convenience. The bag should have a strap that fits comfortably on your shoulder. You should

USING ACCESSORY EQUIPMENT

be able to reach your equipment easily. Remember, however, that easy access for you can mean easy access for others!

Many camera bags look like ordinary shoulder bags. This may be an advantage, because a bag that is a walking advertisement of its contents can be an invitation to theft.

In fact, you can make a camera bag out of an ordinary, sturdy canvas bag, if it has a squared bottom and a reinforced strap. Simply fit a slab of Styrofoam into the bottom, with holes cut out to hold your camera, lenses, and other equipment.

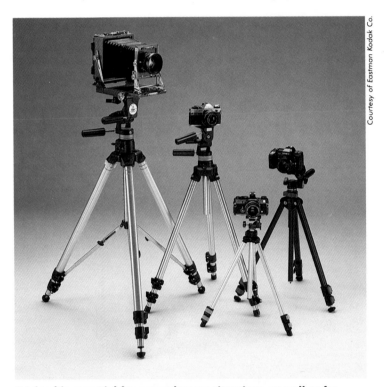

Courtesy of Eastman Kodak Co.

A tripod is essential for many close-up situations, as well as for use with telephoto lenses. A cable release, such as the one shown on page 32, allows you to release the shutter without jarring the camera. In some situations, it may be helpful to use the self-timer and mirror-lock feature of an SLR camera.

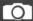

ELECTRONIC FLASH

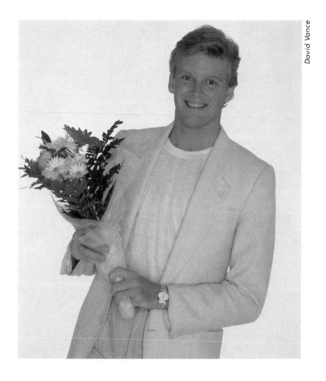

David Vance

Next to a zoom lens, an electronic flash unit is the most important photographic accessory you can have. It increases your control over some technical and creative aspects of your photography, and it extends the range of situations in which you can take photographs.

With a flash unit, you are not at the mercy of existing light. You can supplement existing light, and alter the color, brightness, and character of a scene. You can arrange the lighting direction and control contrast to produce dramatic portraits; you can freeze the rapid beat of a hummingbird's wings or the motion of a tumbling gymnast.

Electronic flash units work by collecting electrical energy in a *capacitor.* After collecting the energy, the capacitor discharges it to the flashtube. The gas in the tube briefly and brilliantly glows. In effect it creates a burst of light. You cannot fire the flash again until the capacitor has recharged. Most flash units have a "ready" light that glows or blinks when the flash is recharged.

The flash from almost all units lasts for an extremely short duration—frequently 1 / 1000 second or less. This short burst of light in effect becomes your shutter speed, so you can freeze motion and minimize the effect of camera shake without the use of a tripod.

Each type of flash unit has its advantages and disadvantages. But no matter what type of flash you own, you can probably use it more effectively.

Have you ever used flash in a dark room or outdoors at night, only to discover later that your subject is washed out and far too light? Or taken pictures where your subjects have vanished into a murky, dark background? If these problems sound familiar, read on.

In Part Two, we will review the most popular kinds of electronic flash units on the market today, such as automatic (including dedicated), manual, and built-in flash, and we'll discuss standard techniques and photographer's tricks that can help you take better pictures.

DETACHABLE FLASH

Detachable battery-powered units are the most popular. Relatively small and portable, they are ideal for most amateur photography.

There are two general types of portable electronic flash units: automatic and manual. *Automatic* units have a sensor that measures the light being bounced back from the subject; the sensor automatically turns off the flash when it has emitted enough light for proper exposure. These units have settings for typical distance ranges. You simply set the aperture according to a calculator on the flash. As long as you stay within the recommended range, exposure will be accurate.

Dedicated flash units are sophisticated automatic devices designed to be used with specific camera brands. When you attach a dedicated flash unit to a camera, the camera automatically sets the shutter to its sync speed and sets the aperture to give correct exposure. With most dedicated units, exposure is determined by a light sensor inside the camera. All you have to do is take the picture. Many automatic and dedicated units also have a manual setting.

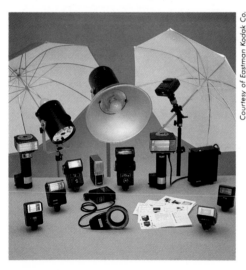

Courtesy of Eastman Kodak Co.

While the basics of operating all electronic flash units are the same, units vary in size, shape, and the features they offer.

Manual units, on the other hand, require you to constantly monitor the flash-to-subject distance and adjust the aperture each time that distance changes. You need to do this because the flash emits the same amount of light each time it fires. You can control exposure only by changing the size of the lens aperture. And the aperture setting you use depends on the distance between the flash and your subject. A calculator scale on the flash indicates the correct aperture for different flash-to-subject distances.

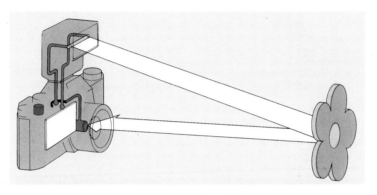

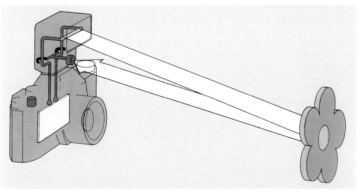

Mounting an electronic flash unit on the camera's hot shoe completes an electrical circuit. The reflected light may be read at the film plane, as in the diagram at the top, or through a sensor on the base of the flash unit, as in the lower diagram.

ELECTRONIC FLASH

You can mount most detachable units directly on a 35 mm camera. If the camera has a *hot shoe,* the electrical connection is automatic. Otherwise, you must connect the flash and camera with a sync (synchronization) cord.

USING AN AUTOMATIC FLASH UNIT

Many automatic flash units are not entirely automatic. You still have to perform a number of operations to use them.

Most automatic units have several mode settings, and each setting is designed for a specific distance range. The setting you use depends on the distance between the camera and the subject, and the depth of field you require.

Automatic units have a sensor that measures the light reflected from the subject and shuts off the flash when enough light has been emitted. These sensors work well for most scenes. However, they can be fooled into providing incorrect exposure. For example, if the scene includes a bright or light-colored object in the foreground, the sensor may read the light reflected from

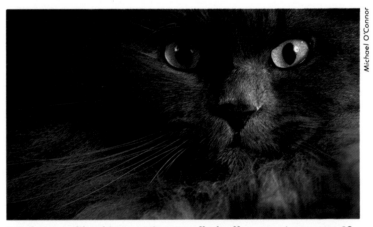

Michael O'Connor

For close-ups like this, try using your flash off-camera (see pages 43 through 46) to keep the light from passing right over the top of your subject's head. This technique also creates interesting modeling on your subject.

USING ACCESSORY EQUIPMENT

this object and underexpose the principal subject that's farther away. Or the sensor may read a large expanse of darkness behind your subject and overexpose the subject. Be aware of such situations and avoid them. If you're in doubt, move your subject or use the manual setting.

USING A MANUAL FLASH UNIT

With a manual flash, you control exposure by setting the lens aperture. Almost all flash units have a dial or some other device that shows the apertures for particular distances and film speeds. If your flash doesn't have such a device, you can calculate the aperture by dividing the guide number by the flash-to-subject distance. Check your flash manual for guide numbers for films of different speeds.

Manual flash operation requires more thought than automatic operation, but it is necessary or useful in several situations:

USE MANUAL FLASH . . .

- when you want to use the maximum output of your flash unit
- when you feel the automatic sensor may be fooled by an unusual situation
- when you are using the bounce-flash technique and the sensor is not facing your subject
- for fill-in flash in bright light
- for multiple flash units

If your automatic flash unit does not have a manual mode, you can obtain full power by covering the sensor with opaque dark tape or your finger when you take the picture.

The following procedure will help you use an automatic (but not dedicated) or a manual flash unit:

ELECTRONIC FLASH

PROCEDURE FOR USING ELECTRONIC FLASH

1. Use fresh batteries so that the flash will recharge quickly after you take a picture.
2. Set the flash calculator dial or scale for the ISO speed of the film you are using.
3. Set your camera to the proper shutter speed for flash sync, usually 1/60 or 1/125 second for focal-plane shutters. The flash-sync speed is usually clearly marked on the camera shutter-speed dial or LCD.
4. Mount the flash unit on the camera hot shoe.
5. Determine the distance from your flash to your subject. (You can focus your camera on your subject, and then check the distance scale on the lens.)
6. Use your flash calculator dial or scale to determine the proper aperture for the flash-to-subject distance, and set your lens at that aperture. FOR AUTOMATIC FLASH: Find the proper power setting for the subject distance on the dial or chart on the flash unit, and set your flash.
7. Turn on your flash and wait for the ready light to glow.
8. Take the picture.

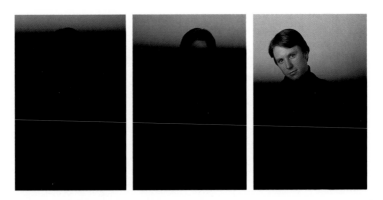

USING ACCESSORY EQUIPMENT

FLASH SYNCHRONIZATION

Using the wrong shutter speed is one of the most common causes of poor flash photos. Camera shutters are located either inside the lens (leaf shutters) or directly in front of the film (focal-plane shutters). Focal-plane shutters require particular shutter-speed settings so that the shutter will be fully open when the flash fires. The correct speed is called the flash-synchronization (flash-sync) speed.

If your flash photographs sometimes have a black band across them, or if a section of the image is completely black, you probably used a shutter speed that was too fast.

Flash-sync speeds vary, but most 35 mm cameras with focal-plane shutters sync at 1/60, 1/90, or 1/125 second. The proper flash-sync speed for your camera should be marked on the shutter-speed dial or LCD. You can use shutter speeds *slower* than the sync speed, but the existing light may create ghost images around the subject, particularly if the subject is moving or the camera is not perfectly still. Leaf-type shutters will synchronize with the flash at any speed, but again, very slow speeds may record ghost images.

If you can't determine the flash-sync speed for your camera, try using 1/60 second.

Courtesy of Eastman Kodak Co.

For proper exposure with an electronic flash unit, set the camera shutter speed at the proper synchronization (sync) speed to insure that the shutter will be fully open when the flash fires. Speeds faster than the sync speed will expose only a part of the film frame.

BOUNCE FLASH

The technique known as *bounce flash* is a simple, very effective method of minimizing the often harsh effects of direct flash, or of supplementing the existing light in a scene. Instead of firing your flash directly at your subject, you reflect—or "bounce"— the light off a large reflective surface onto your subject. Because the light comes from a large area, it has a softer, more even quality. Any reflective surface will help diffuse and spread the light. However, be sure to use a white or light neutral-colored surface, because any color in the reflector will produce a color cast in your photograph. A nearby wall or low ceiling is ideal, but you can also use a white bed sheet or a large piece of white artist's board.

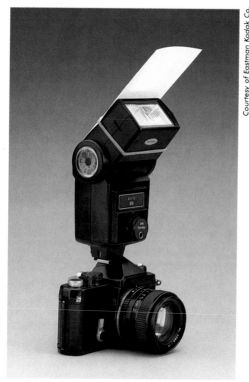

Courtesy of Eastman Kodak Co.

Flash bounced off the ceiling can produce shadows under your subjects eyes. To lighten them, tape a piece of white cardboard to the flash unit so that it extends about two inches beyond the flash head. Some of the light will bounce off the cardboard directly at the subject's eyes.

USING ACCESSORY EQUIPMENT

PROCEDURE FOR USING BOUNCE FLASH

1. Select a nearby white wall, low ceiling, or other large white surface.
2. Be sure that the light bounces off the reflecting surface at the proper angle to light your subject and the area you want to include in your photograph. Test the angle of reflection by firing your flash alone, without making an exposure. FOR AUTOMATIC FLASH: Tilt the flash head toward the bounce surface, and keep the automatic sensor aimed at your subject. If you can't do this with your flash, use the manual mode.
3. Measure or estimate the flash-to-subject distance, being sure to include both the distance from your flash to the reflecting surface and from the surface to your subject.
4. Using your flash calculator dial, determine the proper aperture for the total flash-to-subject distance. Then add approximately 2 stops (increase the aperture by 2 *f*-stops) to compensate for light absorbed by the reflecting surface. A glossy, highly reflective surface may need less compensation; a very textured surface may need more. FOR AUTOMATIC FLASH: Set your flash to the most powerful automatic mode (the mode that requires the largest aperture) to compensate for absorption of light by the bounce surface.
5. Take the picture.

OFF-CAMERA FLASH

If you want to add more interest to your photographs, try removing the flash from the camera and allowing the light to strike your subject from another direction. This technique, called *off-camera flash,* can add impact to your photographs and minimize problems such as red reflections in your subject's eyes (known as *red-eye*).

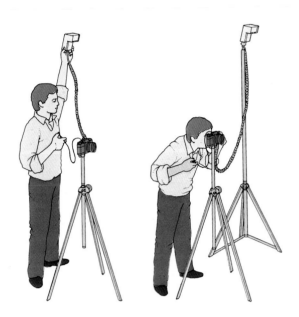

Off-camera flash casts shadows that help to create a three-dimensional effect. For proper exposure, make sure that the flash sensor faces the subject.

The light from a flash unit mounted on the camera casts shadows directly behind the subject. This can flatten the scene and minimize the feeling of depth in the picture. Off-camera flash can add a three-dimensional appearance to your photographs by casting shadows that help show depth and form.

The technique is simple: Position your flash unit away from your camera by holding it out to your side with one arm, or have an assistant hold it. You can also prop it on any flat surface, such as a table, a chair, or—of course—a tripod.

Use an extension cord to position the flash away from the camera while keeping it synchronized with the camera shutter.

In most situations, you can operate an automatic flash unit off the camera and aimed directly at the subject in the same way as if it were on the camera. However, make sure that the flash sensor is accurately aimed at the subject, and the flash-

USING ACCESSORY EQUIPMENT

Direct on-camera flash can be flat and harsh. By holding the flash to one side, you can create modeling on your subject. Interesting shadows bring out form and depth.

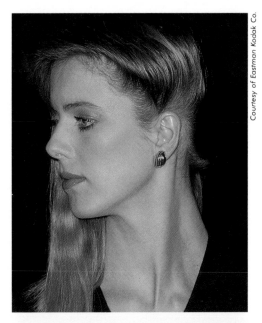

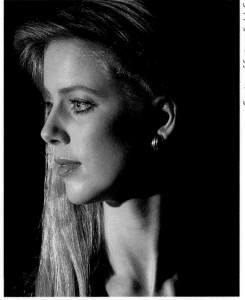

ELECTRONIC FLASH

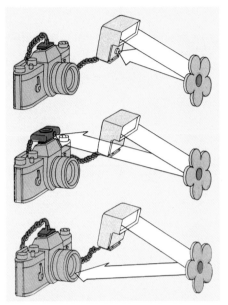

A remote flash sensor mounted on your camera lets you place the flash wherever you want and still get accurate exposure. This is also true of flash units that measure the light at the film plane. If the sensor is on the flash unit, determine the exposure by using the guidelines for off-camera flash below.

to-subject distance is within the allowable automatic range. If your automatic flash unit has a remote sensor, you can keep the sensor on the camera when you detach the rest of the flash. Regardless of the flash position, the sensor will read the light that reaches the lens. Remember to keep the flash within the recommended flash range.

Follow the procedure below with a manual unit or an automatic unit set on manual:

PROCEDURE FOR USING MANUAL OFF-CAMERA FLASH

1. Determine the flash-to-subject distance (not the distance between the camera and the subject).
2. Use your flash calculator dial or scale to find the aperture setting for that distance, and set the aperture.
3. Set the camera shutter to the proper sync speed, and fire away.

USING ACCESSORY EQUIPMENT

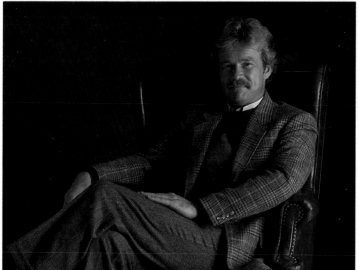

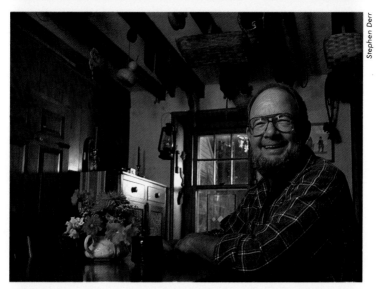

Off-camera electronic flash gives you great control over lighting. The light from the flash resembles daylight and provides natural-looking illumination that is particularly suited to informal portraits.

FILL-IN FLASH

You can use electronic flash to supplement or modify existing light. This technique is known as *fill-in flash* because the light from the flash is used to fill in shadows.

In bright sunlight, flash can reduce harsh contrast and brighten shadows so that they show more detail. With extremely bright backlighting, you'll almost always want to add fill light to show detail in your subject, unless you want the subject to appear as a silhouette.

The key to achieving a natural result with fill-in flash is to use the flash subtly so that the effect of the flash is not obvious in the photograph. A rule of thumb is to set your flash to provide from one to two stops less light than would be required to illuminate the scene by flash alone. If you do a few tests, you will soon learn what ratio of existing light to flash appeals to you.

Fill-in flash is much easier if your flash unit has a selection of automatic mode settings or variable power settings (1/2, 1/4, and so on) in the manual mode. Some SLRs with built-in flash units even have a fill-flash mode. But if your flash unit doesn't have a fill-flash mode, you can still control the intensity of the light on your subject by controlling the flash-to-subject distance in the manual mode. The closer the flash, the brighter the light on your subject.

Remember to use the proper shutter speed (probably 1/125 or 1/60 second) to synchronize your flash with your camera. Slower speeds will also work. However, if you use very slow shutter speeds, areas illuminated by existing light will be exposed for the entire time the shutter is open, and you may record ghost images.

Although shutter speed has no effect on the flash exposure other than synchronization, it does affect the existing-light exposure. By changing the shutter speed (without changing the aperture), you can manipulate the effect of the existing light without altering the effect of the flash. For instance, if you use

USING ACCESSORY EQUIPMENT

You can use electronic flash to lighten shadows on your subject when the sun is the main light source. To use this technique, called fill-in flash, adjust the flash so that it provides 1 to 2 stops less exposure than the exposure from the main light.

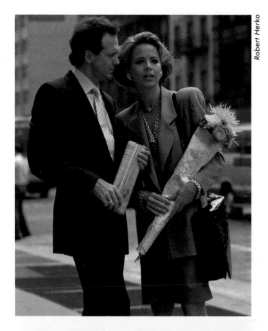

Robert Herko

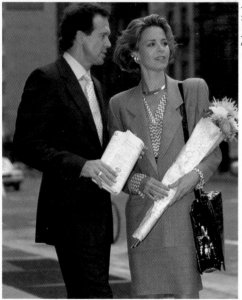

Robert Herko

ELECTRONIC FLASH

André Gallant

Fill light can supplement the main light source to lower scene contrast and increase the relative brightness of shadow areas. The intensity of fill light should be lower than the intensity of the main light.

a slower shutter speed, the area illuminated by existing light (typically the background) will be brighter. With a faster shutter speed (but not above the flash-sync speed), it will be darker. You can produce very dramatic effects, such as deepened colors, or a darkened sky behind your subject.

On cloudy days, fill flash emphasizes a subject by lightening it so that it stands out from the darker background. To obtain pleasing flesh tones, bounce the light or diffuse it by firing your flash through a piece of thin cloth (such as a handkerchief) or translucent paper. These methods will illuminate your subject with a soft, even light.

The following procedure for fill-in flash applies to manual and non-dedicated automatic flash units. If you have a dedicated

USING ACCESSORY EQUIPMENT

flash unit, refer to your flash instruction booklet, or set the unit to manual and follow the procedure for manual flash units. Because this procedure will position the flash at a fixed distance from the subject, you may want to use a zoom lens to vary the image size for better composition.

PROCEDURE FOR USING FILL-IN FLASH

1. Use a film with a speed of ISO 200 or lower so that you don't overexpose areas in sunlight. Set the film speed on the camera.
2. On the flash calculator dial, set the film speed to twice the speed of the film in the camera. For example, if you have ISO 100 film in the camera, set ISO 200 on the flash calculator dial.
3. Set the shutter to its flash-sync speed.
4. Take a meter reading of a sunlit area and set the indicated aperture on the lens.
5. On the flash calculator scale, find the distance corresponding to the f-stop set on the lens. FOR AUTOMATIC FLASH: Set the flash mode. Choose the mode with the aperture that matches or comes closest to the aperture you have set on the lens. Don't use a mode if its aperture is smaller (has a higher number) than that set on the lens.
6. Position the flash at the distance determined in Step 5, turn it on, and take the picture. FOR AUTOMATIC FLASH: Position the flash anywhere within the recommended distance range for the mode you set in Step 5, turn it on, and take the picture.

This procedure will give a natural effect by providing light from the flash that is half as bright as that from the sun. If you want less light from the flash, set the speed on the flash calculator dial to four times the speed of the film in the camera. If you want more light from the flash (equal in brightness to the sunlight), set the true film speed on the flash calculator dial.

Terri Hardin

BUILT-IN FLASH

Many 35 mm cameras—even some sophisticated SLR cameras—have a small built-in electronic flash unit. Although these flashes are useful, they have some drawbacks. For example, the light from a built-in unit is usually much weaker than the light from a separate accessory unit. This means it may underexpose subjects more than about 20 feet from the camera. Its position is also fixed, so you can't tilt it for bounce flash or move it to change the lighting direction.

Built-in flashes offer few controls and are used primarily for taking spontaneous, on-the-spot snapshots. Photographers who want a lot of control prefer detachable flash units.

USING ACCESSORY EQUIPMENT

Fully automatic cameras with built-in flash offer simplicity and convenience. Although you can take good photographs with them, they cannot provide the versatility and flexibility necessary to handle difficult situations. In the photograph below, using built-in flash for a quick snapshot produced unwelcome glare. On the opposite page, built-in flash was used to supplement light coming through the window.

Courtesy of Eastman Kodak Co.

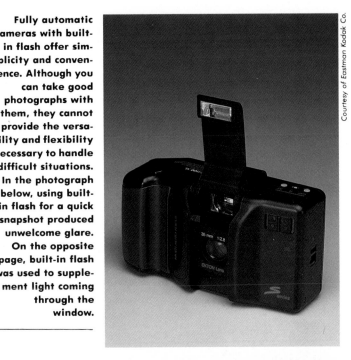

Miguel

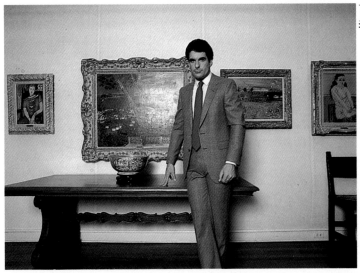

ELECTRONIC FLASH

FILTERS

Frank Whitney

Filters let you add sparkle to a drab scene, change colors, impart a feeling of romance and fantasy, or even rearrange a skyline. They can help fine-tune and subtly refine images, and improve a less-than-ideal situation.

Many types, sizes, and makes of filters are available. Begin by buying a few basic filters from a quality manufacturer. The filters you use don't have to be made by the manufacturer of your camera or lens; many of the highest-quality filters are produced by companies that specialize in filters. Learn how to use your basic filters properly before you move on to more esoteric filters.

Screw-mount filters, the type of filter we will be discussing in this book, are by far the most popular filters for 35 mm photography. Usually made of glass, these filters attach securely to the lens by means of threads on the front of the lens barrel. They come in specific sizes to fit specific lenses, and they are very durable, easy to use, and easy to clean.

To find the proper filter size for your lens, find the diameter of your lens; it should be indicated inside the front of the lens barrel. Frequently, the number is followed by the symbol for diameter. You can also use a single filter with lenses of different diameters if you use an adapter ring.

Purchasing an adapter ring is often more practical and economical than buying several sizes of the same type of filter for different lenses. Make sure, however, that the filter you buy is as large as your largest lens diameter. Otherwise you may see *vignetting*—a dark circle around the edges of your photograph.

To clean a filter, unscrew it from your lens and use either a very soft brush, a blower brush, or compressed air to remove all loose dust and grit. Clean both sides. When you're sure that you've removed all abrasive grit, use a clean sheet of lens-cleaning paper moistened with lens cleaner. Wipe gently and carefully, using a circular motion. Examine the filter by looking through it directly, and by tilting it and studying the surface reflections. After cleaning the filter, immediately remount it on the lens or place it in a clean storage bag or case.

In Part Three, we will discuss popular ultraviolet, polarizing,

color-correction, and diffusion filters, as well as "special effects" filters, such as color, dual-color, split-field, graduated, star, diffraction, and multiple-image filters.

ULTRAVIOLET FILTERS

Ultraviolet (UV) filters are used primarily to reduce the effect of atmospheric haze. By absorbing ultraviolet light, they reduce the bluish cast often evident in photos of distant scenes, such as mountains or skylines. UV filters come in varying strengths, ranging in color from completely clear to faintly yellow.

Most professional and serious amateur photographers keep UV filters mounted on their lenses to protect the lenses from smudges, scratches, dust, and even breakage. Cleaning a filter is safer and easier than cleaning a lens, and it's significantly less expensive to replace a scratched filter than a damaged lens.

The strongest of UV filters are sometimes called *skylight*

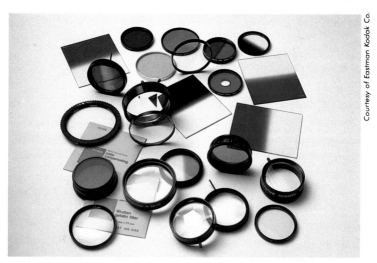

Courtesy of Eastman Kodak Co.

A filter is a transparent device made of glass, plastic, or gelatin. Available in different sizes and shapes to produce a variety of results, filters can lighten, darken, multiply, diffuse, or color an image.

USING ACCESSORY EQUIPMENT

filters: they have a slight warming effect that can be very pleasing. Many photographers use skylight filters to reduce the effects of haze, achieve slightly warmer (redder) skin tones, or offset the cool effect of open shade.

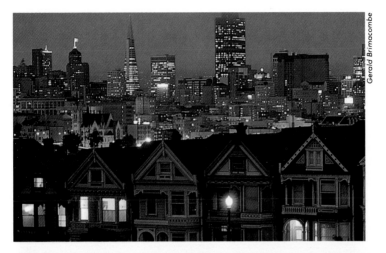

Gerald Brimacombe

Hans Wendler

Some filters can help reproduce the color of your subject accurately. An ultraviolet (UV) filter absorbs ultraviolet light to cut through haze and reduce the bluish cast often found in landscapes and distant scenes.

POLARIZING FILTERS

A polarizing filter (also referred to as a polarizer) is one of the most powerful and useful filters you can own. It is especially effective with color film, but you can also use it with black-and-white film.

A polarizing filter blocks the light rays that vibrate in one direction. It does not change the color of light, but it eliminates glare and reflections from nonmetallic surfaces. In many cases, this significantly increases the saturation of the colors recorded on film.

A polarizing filter can do many things to improve your photographs or solve photographic problems.

A polarizing filter darkens a blue sky and increases color saturation in photographs. When you photograph a light subject against a blue sky, as in the photograph at the left, you can produce dramatic contrast.

WHAT A POLARIZING FILTER CAN DO

- **Increase the strength and intensity (saturation) of the colors in a photograph.** The increased saturation results from decreases in surface glare. Reds become very rich, blues deep and dark, yellows bright and vibrant.
- **Darken a blue sky to increase the drama of a landscape photograph.** A richer, darker sky is usually more attractive, and the contrast between the blue sky and clouds makes the clouds a major element in the image. This increased separation improves black-and-white photographs as well.
- **Minimize or eliminate reflections on shiny nonmetallic surfaces such as windows or water so that you can shoot "through" distracting reflections.** Reflections are a common photographic problem. For instance, suppose you want to photograph a person or a room on the other side of a window, or take a picture of a store display. When you first look through the camera, all you see is the reflection on the surface of the glass. With a polarizing filter, however, you can cut through the reflection to photograph your real subject.
- **Cut through atmospheric haze.** A polarizer is often more effective than a haze filter for color film because it can reduce more scattered blue light.

Using a polarizing filter. Most polarizing filters contain two rings. The inner ring screws onto your lens and remains fixed, and the outer ring rotates. By rotating the outer ring, you increase or decrease the effect of the polarizing filter. The difference should be immediately obvious to you when you look through the viewfinder.

With an SLR camera, using a polarizing filter is simple: Just attach the filter, look through the viewfinder, and rotate the

outer ring until you see the effect you want. With a rangefinder camera, you must look through the filter before you mount it on the lens, and rotate the outer ring until you see the effect you want. Note the orientation of the outer ring by using one of its markings as a guide. Then screw the filter onto your lens, turn the outer ring to the same orientation as before, and shoot away.

The angle of your camera is just as important as how much you turn the filter. The effect of the filter depends on its position in relation to the light source or reflective surface. For instance, when you want to darken a blue sky or increase the saturation of colors outdoors, you produce the most dramatic effects when you take pictures at right angles to the sun when the sun is fairly low in the sky. To find the part of the sky that you can darken most, point your shoulder toward the sun. The sky directly in front of or behind you will show the greatest darkening effect. If the sun is near the horizon, you can also darken the sky overhead.

The most effective position for reducing or eliminating unwanted reflections (in a window, for example) is to stand at an

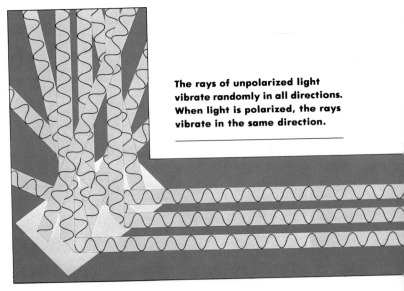

The rays of unpolarized light vibrate randomly in all directions. When light is polarized, the rays vibrate in the same direction.

USING ACCESSORY EQUIPMENT

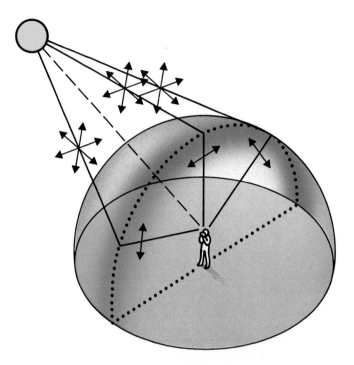

To achieve the maximum effect of the polarizer, position yourself at a right angle to the sun, as in the diagram above. The darkening effect decreases as you face the sun or turn your back to it.

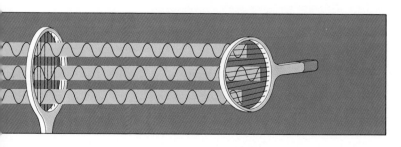

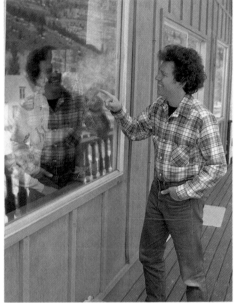

Polarizing filters can reduce reflections from shiny nonmetallic surfaces, such as the glare on the window in the top photograph. The camera angle and the rotation of the filter determine the amount of reduction.

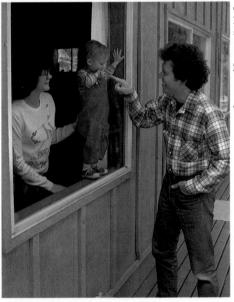

USING ACCESSORY EQUIPMENT

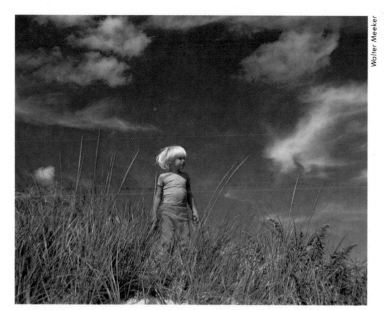

Walter Meeker

A polarizer does not affect the color of light; it alters color saturation. In this photograph, a polarizer was used to darken the blue sky and increase the contrast to produce an image full of color, dynamics, and impact.

angle of approximately 35 degrees from the reflecting surface. Rotate the polarizing filter for maximum effect at that angle.

Because a polarizing filter blocks polarized light, it reduces the amount of light that strikes the film. If your camera has a through-the-lens metering system, it may automatically compensate for the light blocked by the filter.

But if your camera does not make an automatic adjustment, apply a filter factor of 2.5, or increase your exposure by 1 1/3 stops.

Using a polarizing filter may sound complicated at first, but with a bit of experimentation you'll find the technique becoming second nature. Simply rotate the filter, perhaps change your position, and judge the effect. When you like what you see, take the photograph.

COLOR-CORRECTION FILTERS

Light comes in many different colors. The color differences are not always evident to the human eye, but they are obvious to film. This is why films are designed for use with specific types of light.

Conversion filters are used to adapt a film for correct color rendition under light different from the type for which it is intended. For example, if you want to use a film intended for tungsten light, such as KODAK EKTACHROME 160 Film (Tungsten), outdoors in daylight, you can use a No. 85B filter. Common conversion filters are given in the table on page 66.

Determining the correct filtration under fluorescent light is nearly impossible without exact information on the type and brand of tube. Complete correction usually requires combinations of color-compensating filters; when you don't know the type of lamps, the results are far from exact.

Al Satterwhite

You may not notice different colors of light, but your film will. In color photography, you can use conversion filters to obtain good color rendition, whether your film is balanced for daylight or tungsten light.

When daylight film is exposed under fluorescent light, the image takes on a green cast, as in the photograph at the top. You can use color-compensating filters to produce accurate color, but each type of fluorescent lamp requires a different combination of filters. If you don't use filters, shoot your pictures on color-negative film, which can be color-corrected during printing.

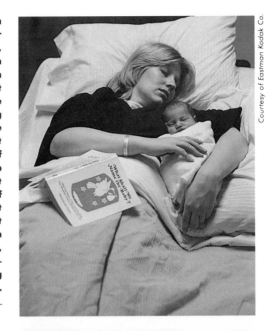

Courtesy of Eastman Kodak Co.

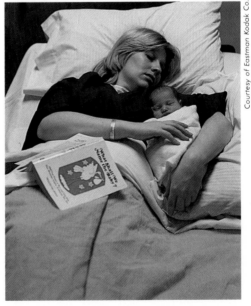

Courtesy of Eastman Kodak Co.

FILTERS

CONVERSION FILTERS

Film Balanced For	Light Source		
	Daylight or Electronic Flash	Tungsten (3200 K)	Photolamp (3400 K)
Daylight	None	80A	80B
Tungsten (3200 K)	85B	None	81A
Photolamps (3400 K)	85	82A	None

DIFFUSION FILTERS

Diffusion filters soften, or diffuse, an image. They are available in a number of strengths: A No. 1 soft filter is the weakest and most commonly used. The stronger types—No. 2 and 3—are sometimes called *mist* or *fog filters,* and they are most often used for romantic landscape or scenic photography. The diffusion effect of a fog filter is too strong for most photographs of people.

Diffusion filters scatter and spread light. Diffusion is particularly noticeable around bright spots, where highlights show distinct flare, somewhat like a halo.

Photographs made with a diffusion filter may look fuzzy, but they are actually properly focused. Some diffusion filters have a clear central area to produce a sharp image in the middle of the photograph with increased diffusion toward the edges.

You can buy diffusion filters from a number of manufacturers, or you can make your own. Many professional photographers spread petroleum jelly (or spray clear hair spray) on a clear UV filter. Try it! Then look through the filter to see the effect; if you don't like the results, or when you are finished using the filter, simply clean it.

Making your own diffusion filters lets you produce any effect

USING ACCESSORY EQUIPMENT

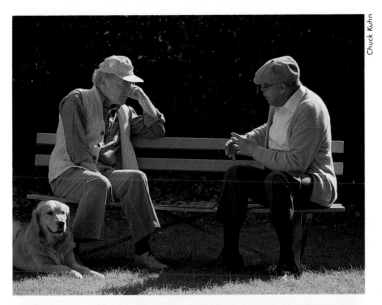

Chuck Kuhn

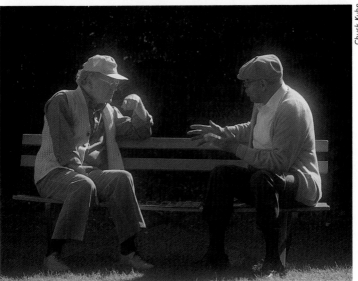

Chuck Kuhn

Note how a diffusion filter softened the image in the lower photograph.

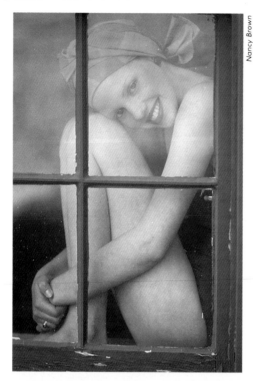

Nancy Brown

Portraits made in the early days of photography appeared soft because long exposure times were required. Today, portraits made with a diffusion filter, such as the one at the left, have a traditional charm and appeal. You can also use a diffusion filter to make objects such as the flowers below appear romantic.

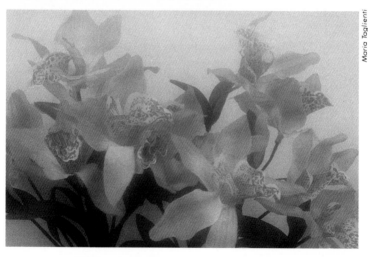

Maria Taglienti

USING ACCESSORY EQUIPMENT

you want. For instance, you can make a filter to diffuse only certain areas of an image and leave the rest sharp. Or you can add a tint to your photographs by mixing a bit of color into the petroleum jelly. You can even create light streaks by smearing the coating in a particular pattern.

FILTERS FOR SPECIAL EFFECTS

A number of filters (and other lens attachments) produce special photographic effects. Filters can add rainbows, stars, or a feeling of movement in stationary subjects. Other filters allow you to turn a single church steeple into a mass of steeples.

Most special-effects filters are available in different types— as individual filters that attach to your lens one at a time, or as comprehensive systems with holders that allow you to use a number of filters at the same time. You can also make your own special-effects filters from textured glass, window screen, colored cellophane, or transparent tape. You can probably think of many other materials to use for special effects: the possibilities for these homemade filters are as broad as your imagination and ingenuity.

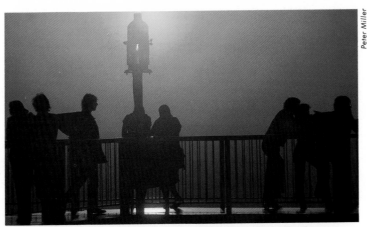

Peter Miller

A color filter transmits its own color while absorbing all others. A red filter was used to add impact and drama to the silhouette.

While special-effects filters have their place, use them with caution and intelligence. Extreme effects can easily become gimmicky; if every picture you take has stars in it, the drama wears off quickly. You should learn quickly when and when not to use them.

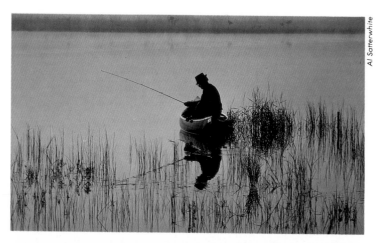

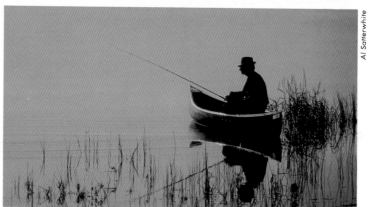

Color helps to convey mood. Green indicates serenity; orange, as shown above, gives the scene an autumnal feeling. The effect of color filters can be subtle or obvious, depending on the density of the filter you select. Be sure to choose a filter that will reinforce the intended mood.

Color filters are available in many varieties, including *single-color, dual-color,* and *graduated.*

A single-color filter gives the scene an overall tint of one color. A red filter will bathe your photograph in red tones, giving it a kind of feverish drama; a blue filter will cool everything down, giving it a twilight-like, ethereal look. The technique is simple— just attach the filter—but the results are often astounding.

A dual-color filter combines two colors and gives you other creative options. There is a distinct line on the filter where the colors meet, so you must be careful where you place it in the scene. A photo of a person bisected by blue on one side and yellow on the other can look odd! You might try placing the line in a dark area of your scene, where it will be concealed. If the scene has an unencumbered horizon, such as a sunset over the ocean, try placing the dividing line on the horizon.

While both single-color and dual-color filters have the same density of color throughout, graduated filters are part clear and part gradually denser color with a feathered edge between the two parts. Most graduated filters have rotating mounts that let you change the orientation of the filter without removing it from the lens.

Graduated filters are commonly used in landscape photography to add color to a bland or white sky while keeping natural color in the landscape.

Some graduated filters have an area of neutral density rather than a color. You can use these filters to modify the contrast and reduce the exposure of one area of your photograph while the rest of the scene remains unaltered. These filters are ideal for darkening a background sky or sunset while maintaining detail in the foreground.

Split-field filters, or split-field lenses, offer two fields of focus in one filter—one for near subjects and one for distant subjects. One half consists of a close-up lens, and the other half is clear or open (no glass). These lenses let you retain sharp focus from a few inches from the camera to infinity to produce dramatic

depth-of-field effects. You can also use split-field filters without nearby subjects for deliberate out-of-focus effects. They are available in many strengths, such as +1/2, +1, +2, +3, and +4 *diopters.*

Only half of a graduated filter is colored. In the photograph at the top, a red graduated filter exaggerated the contrast between the sky and the landscape. In the lower photograph, a dual-color filter was used to bring the seascape to life. Each half of a dual-color filter contains a different color.

USING ACCESSORY EQUIPMENT

Star filters produce lines that radiate from small, extremely bright areas or light sources, making them look like stars. The number of lines or points depends on the filter; 4-, 6-, 8-, and 12-point star filters are the most popular. During manufacture, a thin cross-hair grid is etched or embossed on the glass, or a thin piece of screen is enclosed between two pieces of clear glass. The smaller the grid or screen, the more stars the filter produces. You can vary the angle of the stars by rotating the filter.

You can make your own star filters from a piece of common window screen. Simply hold the screen in front of your lens, or attach it to an adapter ring or clear filter that screws onto your lens. With a little experimentation, you will discover the effects that different screens produce.

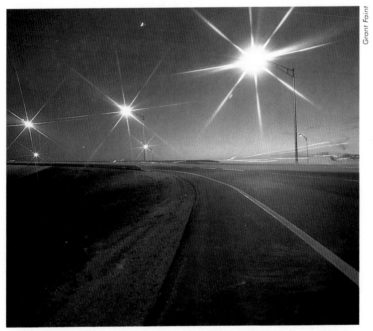

Grant Faint

A star filter contains a fine metal mesh that makes bright points of light look like stars.

By exaggerating specular highlights in the landscape, a star filter produces exciting images.

The orientation of the radiating lines depends on the rotation of the filter on the lens. The size of the star depends on the brightness of the light source, the distance of the light from your camera, and the aperture. Brighter or closer light sources and larger apertures produce bigger stars. With an SLR camera, preview the effect by stopping the lens down to the chosen aperture with the depth-of-field preview button.

The stars are more obvious when the light source at the center is surrounded by a much darker area. Street lamps at night are ideal subjects. For a more subtle effect, use a star filter to photograph sunlight reflected off water. The stars created by the highlights will add sparkle and life to the image.

Diffraction filters produce an effect similar to that created by star filters, but add rainbow-like colors to the stars. The intensity of the colors depends both on the strength of the light source and on the degree of contrast between the background and the streaks of light radiating from the light source. A bright

USING ACCESSORY EQUIPMENT

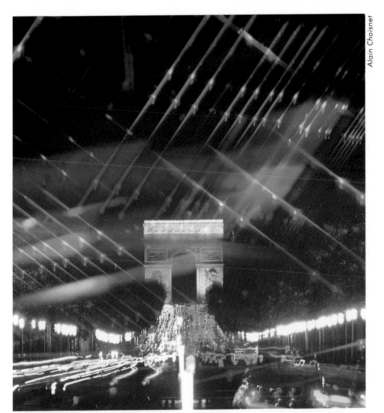

Tiny ridges on the surface of a diffraction filter produce streaks of multicolored light that radiate from specular light sources.

light source against a dark background provides the most pronounced effect. When you're using a diffraction filter, select as dark a background as possible; for maximum effect, underexpose your photographs by one or two stops.

Multiple-image filters produce multiple copies of a single image. The effect is similar to that of multiple exposures on the same frame of film. One automobile, for example, will appear as three, four—or even more—identical automobiles in your picture.

These filters come in many varieties. They have multiple facets, angles, and surfaces; you can easily predict their effect by looking at the surface. And if you have an SLR camera, you can see everything a multiple-image filter will do by looking through your lens with the filter attached. Some filters produce four

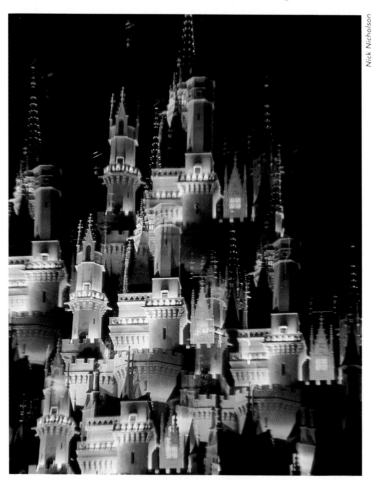

Nick Nicholson

Some multiple-image filters produce one central image surrounded by identical images. Other multiple-image filters can produce images in concentric, radial, and linear patterns.

USING ACCESSORY EQUIPMENT

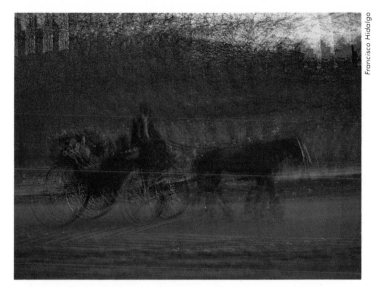

Francisco Hidalgo

In the photograph above, a multiple-image filter gave the scene the look of an impressionistic painting.

identical images; others show three identical images in a circular (thirds) pattern. Certain multiple-image filters give a motion effect by repeating identical images in a row, while others place the images in distinct areas of your photograph. Still others allow you to overlap the images.

The effect you create depends on the subject, the rotation of the filter, and the aperture of your lens. You will want to pay close attention to these other elements to get as pleasing an image as possible.

CONCLUSION. Now that *Using Accessory Equipment* has introduced you to the most popular types of accessories, you'll probably want to experiment with more exotic ones, such as *gyroscopes* (used in aerial photography) and *magnifying prism viewfinders* (used in underwater photography). Chances are you'll find that your favorite accessories are a happy mixture of the complicated and the commonplace.

GLOSSARY OF TERMS

Adapter rings—Devices that allow you to attach a filter to lenses of varying diameters.

Angle of view—The extent of the area "seen" by a lens.

Aperture—Lens opening. The opening in a lens system through which light passes. The size is either fixed or adjustable. Lens openings are expressed as *f*-numbers.

Autofocus—Used to describe cameras that focus automatically on the subject when you aim the camera so that the subject is within the autofocus marks or brackets in the viewfinder.

Automatic flash unit—A flash unit with a sensor that measures the light reflected from a scene or the light at the film plane and shuts off when the proper amount of light has been emitted.

Bellows—A lighttight expandable tube used between the lens and the camera body to produce high levels of magnification in close-up photography.

Bounce flash—A technique in which flash is directed at (or "bounced" off) a large reflective surface to provide softer, more diffused illumination.

Bracketing—Making extra photographs at exposure settings to provide more and less exposure than the calculated or recommended setting—for example, at +1, +2, −1, and −2 stops from the calculated setting.

Built-in flash unit—A non-detachable unit that is a part of some camera models. It is usually turned on by a button, but some units will automatically activate when the meter determines that the scene is too dark for proper exposure without flash.

Cable release—A thin cable that lets the photographer trip the shutter without touching the camera; used to avoid camera movement at slow shutter speeds.

Capacitor—The part of an electronic flash unit that stores an electric charge.

Clamp-pod—A camera support that attaches to a surface by means of a clamp.

Close-up lens—An attachment that permits taking pictures at a closer distance than the lens alone will allow.

Color-negative film—A film that is processed to a negative image, from which positive prints are made.

Conversion filter—A filter used to balance film to a light source different from the source for which it is designed.

Daylight-balanced film—Film balanced to produce accurate color rendition in daylight or with electronic flash.

Dedicated flash—An automatic flash unit designed to work with a specific brand or model of camera. It exchanges information with the camera to set the proper exposure.

Depth of field—The distance between the nearest and farthest objects in a scene that appear in acceptable focus in a photograph.

Diffraction filter—A filter inscribed with parallel grooves that break up white light to create prism-like effects in highlights.

Diffusion—Softening of detail in a photograph by using a diffusion filter or other material that scatters light.

Diffusion filter—A type of filter that diffuses light. Diffusion filters come in varying strengths: No.1 is the weakest; mist and fog filters are considerably stronger.

Diopter—The reciprocal of lens focal length expressed in meters.

Direct flash—Flash that strikes the subject directly.

Dual-color filter—See "Filter."

Electronic flash—A brief but intense burst of light from the flashtube of a flash unit; supplements existing light or provides the main light on the subject.

Exposure—The amount of light that acts on a photographic material; a product of the intensity (controlled by the lens opening) and the duration (controlled by the shutter speed) of light striking the film.

Exposure meter—An instrument—either built into a camera or a separate, hand-held unit—used to determine the aperture and shutter speed for proper exposure.

Extension rings—Tubes that adapt a lens for close-up photography; reversing rings reverse the lens for the same purpose.

Fill-in flash—Light from a flash unit that is used to brighten shadows created by the primary light source.

Film speed—The sensitivity of a film to light, indicated by an ISO number.

Film-speed setting—A camera setting—either manual or automatic—that tells the camera the speed of the film.

Filter—A piece of colored glass or other transparent material used over the lens to emphasize, eliminate, or change the color or density of the entire scene or certain elements in the scene.

Fisheye lens—An extreme wide-angle lens covering an angle of 180 degrees and creating distortion in the image. A full-frame fisheye fills the entire 35 mm format; a standard fisheye creates a greatly distorted circular image.

Flash calculator dial—A control on a flash unit that tells the correct aperture for the camera-to-subject distance, or the correct distance range for a particular aperture.

Flash-synchronization (sync) shutter speed—The speed at which the shutter is synchronized with the firing of the flash.

Flashtube—The gas-filled tube of an elec-

tronic flash unit that emits a short, intense burst of artificial light.

Flatness of field—A property of lenses that can record an image that is sharp both at the center and at the edges on a flat film or plate.

f-**number or** *f*-**stop**—A number used to indicate the size of the opening on most lenses. Common *f*numbers are *f*/2, *f*/2.8, *f*/4, *f*/5.6, *f*/8, *f*/11, *f*/16, and *f*/22. The higher the *f*-number, the smaller the lens opening.

Focal length—The distance from the optical center of a lens to the film plane when the lens is focused at infinity.

Freezing action—A technique that makes an object in motion appear "stopped"; can be accomplished by using a high shutter speed or electronic flash.

Gyroscope—A wheel mounted within a set of rings used in aerial photography to steady the camera.

Hot shoe—A fitting on top of a camera that provides electrical contact between an electronic flash unit and the camera shutter.

ISO speed—A system of the International Organization for Standardization for measuring film speed.

Lens—One or more pieces of optical glass or similar material that collects and focuses rays of light to form a sharp image.

Lens hood—An accessory that shields the lens from stray light to prevent flare.

Macro lens—A lens specifically designed for close-up photography.

Magnifying prism viewfinder—An attachment that magnifies the image seen through the viewfinder.

Manual exposure control—A system that allows the photographer to adjust aperture and shutter speed manually.

Manual flash—A flash unit that emits the same amount of light each time it fires.

Monopod—A one-legged camera support with a hinged head to which the camera is attached.

Multiple-image filter—A filter whose surface is cut to create multiple images.

Normal lens—A lens that produces an image with perspective similar to that of the original scene.

Off-camera flash—Using a flash unit off the camera to provide sidelighting, bounce lighting, or other directional lighting.

Overexposure—A situation in which too much light reaches the film, producing a dense negative or a light slide.

Point-and-shoot camera—An automatic non-SLR camera, usually with built-in flash.

Polarizing filter—A filter that blocks polarized light; used to darken a sky or eliminate reflections from nonmetallic surfaces.

Rangefinder—A focusing device on non-SLR cameras. The photographer aligns two images of the subject for proper focus.

Red-eye—A phenomenon caused by reflection of the flash by blood vessels in the back of the eye.

Reflector—Any device used to reflect light onto a subject.

Reversing rings—See "**Extension rings.**"

Screw-mount filter—A filter with a threaded ring that screws directly into the lens barrel.

Single-lens-reflex (SLR) camera—A camera that uses a prism and mirror to provide viewing through the lens.

Skylight filter—The strongest type of ultraviolet (UV) filter.

Split-field filter—Sometimes called a lens, a filter that is half close-up lens and half clear or open (no glass); keeps both close foreground and far background in focus.

Star filter—A filter with horizontal and vertical lines etched into its surface that makes specular light sources look like stars.

Stop(s)—Exposure increments. Each single-increment change in shutter speed or aperture represents one stop, and halves or doubles the amount of light striking the film. (Also see "*f*-**stop.**")

Sync (synchronization) cord—An extension cord that connects the camera to a flash unit to provide electrical contact and synchronization with the shutter.

Telephoto lens—A lens that creates a larger image of the subject than a normal lens at the same camera-to-subject distance.

Through-the-lens meter (TTL)—A built-in camera meter that determines exposure by reading the light passing through the lens.

Tripod—A three-legged camera support with a rotating hinged head to which the camera is attached.

Tungsten-balanced film—Film that has been balanced to produce accurate color rendition under tungsten light.

Tungsten light—Light from normal household lamps and ceiling fixtures (not fluorescent).

Ultraviolet (UV) filter—A filter used to cut through haze and eliminate the blue cast often seen in scenics or photographs made in open shade.

Underexposure—A condition in which too little light reaches the film, producing a thin negative or a dark slide.

Vignetting—Darkening or lightening around the edges of an image produced by masking during printing or using a filter with a smaller diameter than that of the lens.

Wide-angle lens—A lens that covers a wider field of view than a normal lens at the same subject distance.

Zoom lens—A variable-focal-length lens that can be used in place of a number of individual fixed-focal-length lenses.

INDEX

Please note: Entries which appear in bold refer to captions.

USING ACCESSORY EQUIPMENT